This exercise book now belongs to you!

FANG NIE AN, "AUFZUHÖREN HOP NIE AUF ANZUFANGEN.

MARCUS TULLIUS CICERO

Never start quitting,
Never quit starting.

The Secret of Getting Ahead is Getting Started.

MARK TWAIN

PREFACE

Nothing describes the first steps in hand lettering better than this quote from the American author Mark Twain – because practice is the key to the joys of hand lettering.

To make it easier for you to practise, I have compiled this exercise book with lots of examples – with plenty of space for you to write too. Like this, you can learn the basics of hand lettering step by step. I have deliberately kept the theoretical part of the book short, so that you can get started straight away. In the practice section you will find a number of sayings, which you can use according to the motto "copy and learn", first tracing the letters and then drawing them yourself. There is also plenty of blank space for creating your own letters and, of course, an A-Z guide of letters.

It would help if you can practise every day – although you don't have to invest hours and hours right away (but you can if you like, of course ☺). To improve your skills, however, it is enough if you pick up your pens for a few relaxing minutes every day and consciously familiarise yourself with the exercises for flourishes and the letters. Naturally, the more you practise, the faster you will perfect your hand lettering.

But be careful: no one is born a master. Don't compare yourself to other hand lettering artists, but view your work compared to your own first attempts. You will soon see that you are making progress. What is more, it doesn't always need to be perfect. If you like what you have created, it is fine as it is. And think about the fact that it should be fun and then you will hopefully be able to relax and unwind when you are hand lettering, just like I do.

With this in mind, I wish you **HAPPY LETTERING!**

Katja

Materials & Equipment

MATERIALS & EQUIPMENT

First of all, a quick overview of materials and equipment. This selection is based on my personal preferences and is not a "must have" that you need to start hand lettering. There are, of course, numerous pens, brushes, types of paper and paints – also produced by other manufacturers – which are perfectly suitable for hand lettering.

Basic equipment

- Pencil
- Fineliner
- Brush pens
 Whether you choose brush pens with felt sponge tips, with individual fine hairs or even regular felt tips – you can practise brush lettering with all these writing instruments, it depends entirely on your personal preference.
- Dip pens (e.g. Nikko G)
- Pens holders (straight or oblique)
- Ink (e.g. Higgins Eternal Ink)

- Paper to practise
 Marker paper or high quality, very smooth laser printing paper is particularly suitable for brush pens with synthetic tips that are sometimes very delicate. Transparent paper can also be used and has the advantage that you can trace or copy the shapes of the letters even without a light pad. This can be highly advantageous for the final artwork and also for scanning.
- Eraser
- Ruler/set square
- Washi tape

If you would like specific recommendations for materials, you are welcome to have a look on my website at **www.papier-liebe.at/ produktempfehlungen** where you will find a list of my personal favourites which is constantly expanded.

GRIDS

In this exercise book, I will spare you a lengthy introduction to the structure and anatomy of the various types of script – of course it is not an unimportant subject – but I think that you are keen to start your first practice exercises, aren't you? :)

Just a quick reminder to help you: **the "grid"**

All the letters sit on the baseline and are arranged in a grid with three sections. Lower case letters reach the waistline, upper case letters and letters with ascenders (e.g. "b", "d", "l") reach the top line, letters with descenders (e.g. "g", "j", "y") reach the beard line.

The slant line gives the angle at which the letters are written. Ideally, place your sheet of paper in front of you in such a way that the slant lines appear more or less vertical.

Tip! You can also download all the grids in this exercise book from my website **www.papier-liebe.at /vorlagen**

TIP:
Stick your practice sheet to the grid with a piece of washi tape, so that the grid cannot slip while you are writing. When you have finished you can simply remove the tape and the grid.

For the **warm-up exercises** on the following pages, I recommend that you use a pencil that is not too hard, or a fineliner. Take plenty of time for the exercises and do them slowly and deliberately. These basic exercises serve as the basis for all the letters.

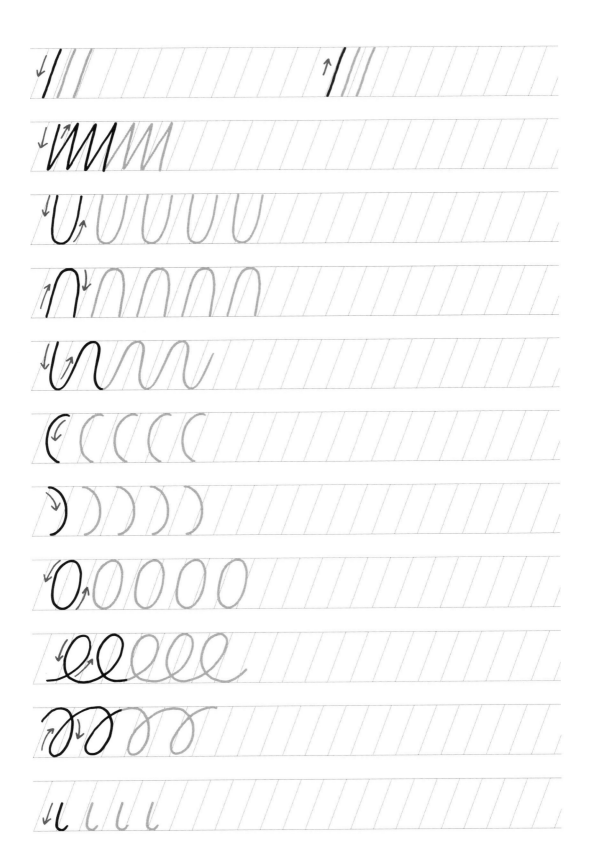

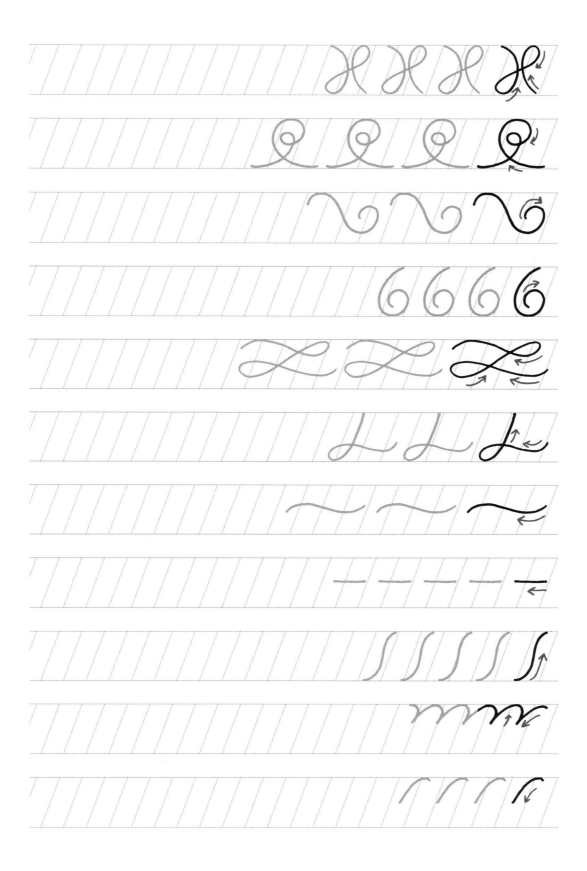

Grids for you to practise

FAUX CALLIGRAPHY

"Faux calligraphy", which is also known as "fake calligraphy", is particularly helpful in order to better understand the principle of the so-called swell stroke. You can use this technique with any writing instrument of your choice (e.g. pencil or fineliner). It is also particularly good for writing on surfaces that are not suitable for brush pens or dip pens, such as wood or chalk boards. Apart from this, it also allows you to produce a lot of additional designs. In any case it is fun to experiment with this technique.
Here is what you do:

Step 1: **First of all, write the desired letters or word**

be happy

Step 2: **Reinforce all the downward strokes with a second, offset line.**

be happy

Step 3: **The spaces that you have created between the lines are now filled in.**

be happy

Step 3a: **You can also fill in the spaces using colour or a pattern (e.g. dots or stripes).**

a a a **a** b b **b**

c c **c** d d **d**

e e **e** f f **f**

g g **g** h h **h**

i i **i** j j **j**

k k **k** l l **l**

m m **m** n n **n**

o o **o** p p **p**

q q **q** r r **r**

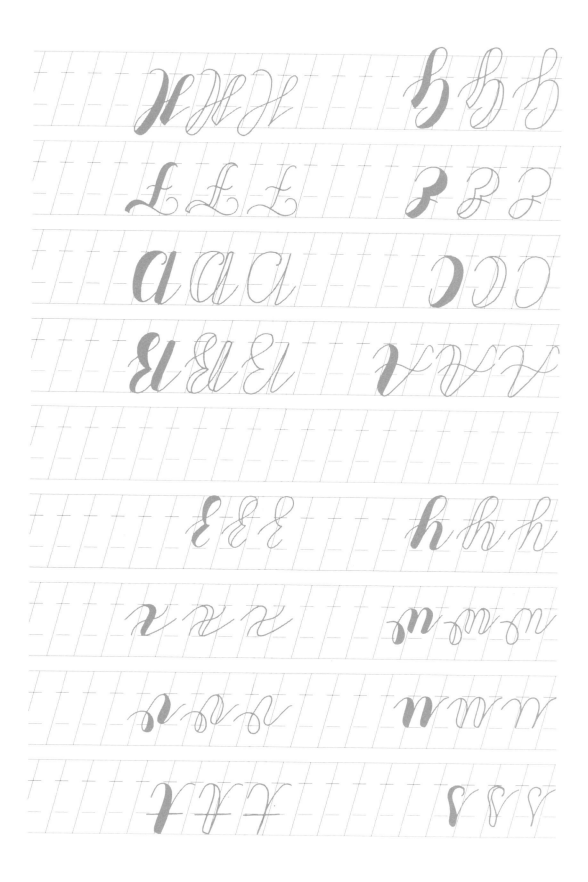

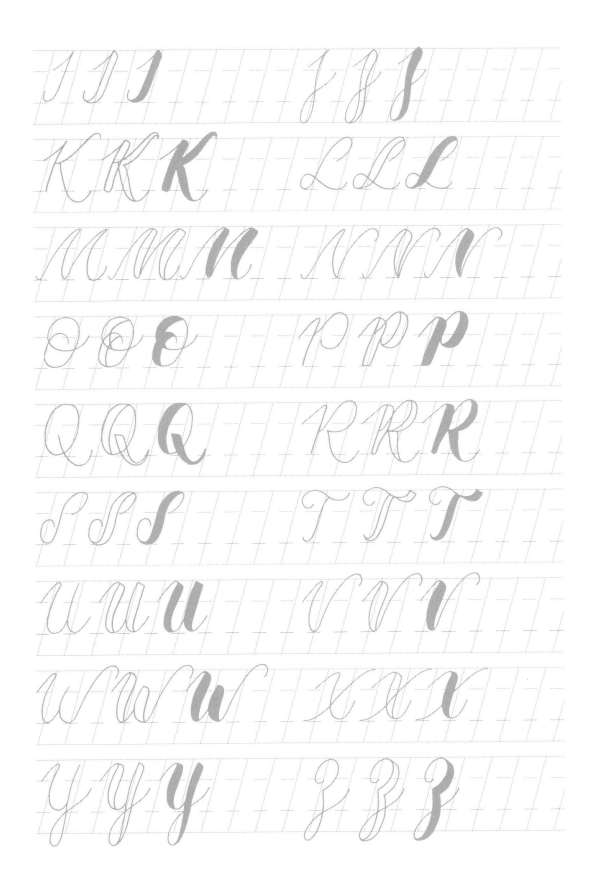

Draw all the letters again here in any order you like and decorate them individually. You can use your imagination and choose any pattern or colour you prefer...

Tip! If you do not want to decorate or colour in the spaces afterwards, try to avoid unsightly overlaps from the start or remember to correct them when you are drawing the final version.

BRUSH PENS

What to do: for the downward stroke, press the tip of the brush pen firmly on the paper in order to create a thick line. For the upward stroke, let the tip glide softly over the paper, so a thin line is created.

DOWNSTROKE
(Downwards stroke)

UPSTROKE
(Upwards stroke)

Templates for small brush pens (e.g. Pentel Sign Pen or Tombow Fudenosuke soft/hard)

You can practice here!

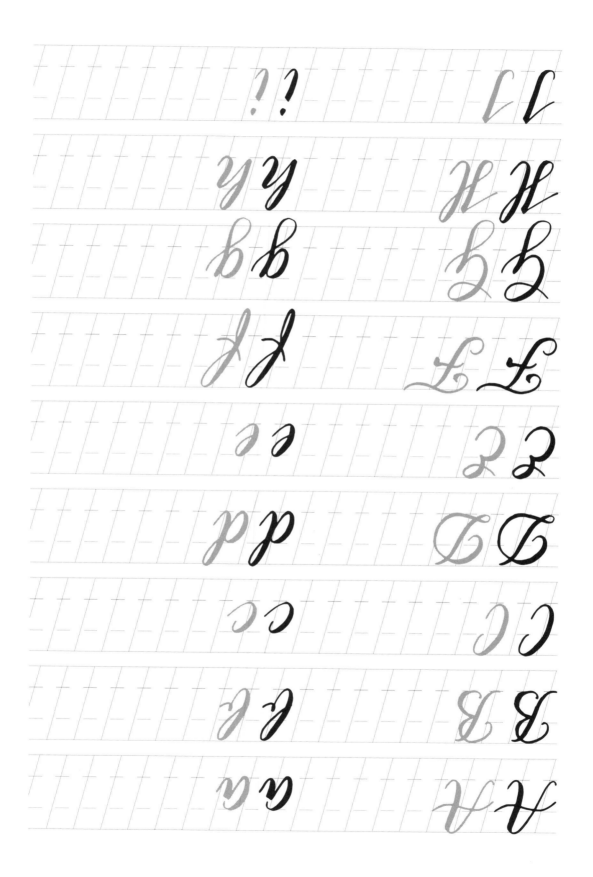

J J j j

K K k k

L L l l

M M m m

N N n n

O O o o

P P p p

Q Q q q

R R r r

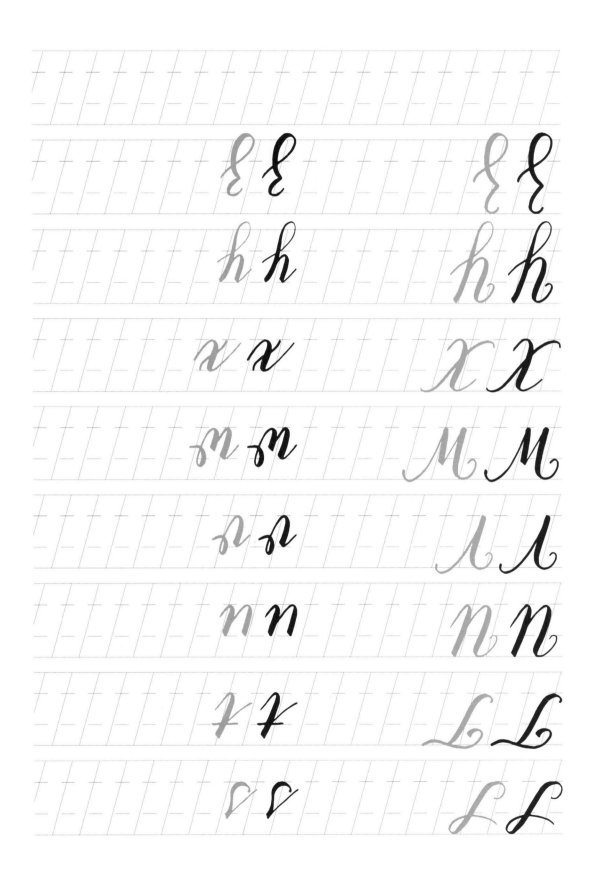

Franz jagt im komplett verwahrlosten Taxi quer durch Bayern.

The quick brown fox jumps over the lazy dog.

Now it's your turn again: write this pangram (a sentence containing every letter of the alphabet) in the grid below.

On this page, we will write a few names to practice the links between the individual letters (letter transitions). I have compiled them for you at random in alphabetical order.

Anni Bernhard

Claudia Daniela

Erwin Felix Gitti

Hannes Ida Julia

Katja Linda Manuel

Nina Otto Philipp

Quirinius Renate

Sabine Tanja Udo

Valentina Wilhelm
Xaver Yvonne Zita

Which other names can you think of?

SANS SERIF FONTS

Sans serif fonts have a trendy, up-to-date appearance and can be combined to great effect with decorative or ornate lettering. You can make the letters narrow or wide and you can also vary the x-height so that you create a new look every time.

Templates for fineliners (e.g. PIGMA MICRON 08)

AA AA AA aa

BB BB BB bb

CC cc DD dd

EE EE EE ee

FF FF FF ff

GG gg II ii

HH HH HH hh

JJ jj LL ll

KK KK KK kk

M M M M M M m m

N N N N N N n n

O O o o Q Q q q

P P P P P P p p

R R R R R R r r

S S s s T T t t

U U u u V V v v

W W W W W W w w

X X x x

Y Y Y Y Y Y y y

Z Z Z Z Z Z z z

With this alphabet in sans serif, I didn't pay attention to the weight of the upstrokes and downstrokes. If you also take this into consideration, you can create one or several wonderful combinations of letters. Just as with faux calligraphy, you can embellish and decorate the reinforced spaces between the strokes individually.

Try it out now: draw a few letters or a complete word in sans serif with individually decorated downstrokes. Depending on the size of the letters you can really go into detail here.

SERIF FONTS

The small transverse strokes (little "feet") attached to the ends of letters are known as serifs. There are different ways of drawing these serifs. I usually use simple straight serifs.

Tip!
With serif fonts, you can also make the x-height variable and thus constantly create new styles of writing.

Templates for fineliners (e.g. PIGMA MICRON 08)

A A A a a a

B B B b b b

C C C c c c

D D D d d d

E E E e e e

F F F f f f

G G G g g g

H H H h h h

I I I i i i

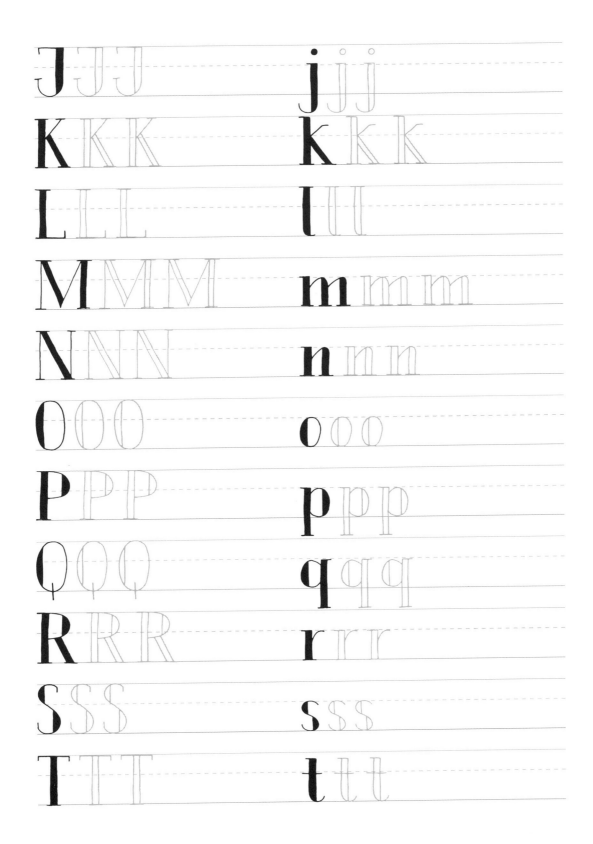

J J J j j j

K K K k k k

L L L l l l

M M M M m m m

N N N n n n

O O O o o o

P P P p p p

Q Q Q q q q

R R R r r r

S S S s s s

T T T t t t

Z ZZZ Z ZZ

Y YY y hh

X XXX X XXX

W WWW W WW

V VVV V VV

U UUU U UU

Now have a go using your name!

SERIFS

There are different kinds of serifs. If you want to use capital letters or block capitals in your lettering composition, you can have great fun playing around with serifs. You can also use them with lower case writing of course – but this is something of a Sisyphean task for reasons of space. Here are a few examples so that you can familiarise yourself with popular forms of serifs.

Perhaps you also have some ideas for creating your own style of serifs?

ich mag nashörner. die sind wie einhörner. nur fetter.

I like rhinoceroses. They are just like unicorns. Just fatter.

Now it's your turn again! Here you have space for your lettering project with serifs.

DESIGN OPTIONS

Width of characters and strokes, flourishes, patterns, configurations, lines, dots and shading – here you have a brief overview of a range of design options. You can use these to vary, embellish and add emphasis to your letters.

Vary the **character width**...

... and/or the **stroke weight**

wide Character width narrow

thin Stroke weight bold

Work with **inlines** and **outlines**

Use **shadows** and **3-D effects**

Flourishes look good too!

... and **dots, stripes and shading**

You use a **ligature** to connect two or more characters in one stroke. The best-known ligatures are the ampersand (&) and the "ß", which is used in German.

Ligature

Decorate these letters however you like and create your own designs for letters.

NUMBERS AND SPECIAL CHARACTERS

Numbers and special characters expand your repertoire in hand lettering and they are indispensable for certain occasions or also for addressing envelopes. You can play around with numbers and special characters using them as a highlight or text breaker. Here are a few examples of variations on numbers for you to copy and draw yourself.

NARROW & WITH SERIFS

1 2 3 4 5 6 7 8 9 0

NARROW & SANS SERIF

1 2 3 4 5 6 7 8 9 0

CALLIGRAPHIC

1 2 3 4 5 6 7 8 9 0

Special characters

. : , ; ! ? % & / () € = + * # @

Use this page to practice different numbers and special characters.

ALTERNATIVE GRIDS

To bring even more excitement and creative freedom to your hand lettering project you can also work with an alternative grid, such as you see here, using a wavy line or a circular design.

Today is your day

Heute ist dein Tag

Today is your day

HEUTE ist DEIN TAG

You can also use a combination of oblique lines for your grid ...

Heute ist dein Tag

Today is your day

Or choose a completely free design.

Heute ist dein Tag

Today is your day

Here you have space to practice your own grid design.

Choose a saying and create a design using an alternative grid on this page ...

Unleash your imagination!

BOUNCE LETTERING

If you want to add a more individual flavour to your lettering projects, try using "hopping" letters. That may sound a bit strange, but I find it a really enjoyable creative technique. Here, we are abandoning the idea of aligning all the letters on the baseline. This quickly adds more dynamism to our work since we are also playing around with the letters. Here is an example to help you understand better:

Bounce Lettering

All the letters are aligned on the baseline

ALIGNMENT ON THE BASELINE

Letters not aligned in a uniform way on the baseline.

Bounce Lettering

HOPPING LETTERS

If you hear butterflies laughing you know how clouds taste

Here you can trace the saying – according to the motto "copy and learn"

Use this space to practise!

DECORATIVE FEATURES

You can give your hand lettering an appropriate "frame" or link the individual words together visually by using banners, tendrils, garlands and other decorative features. Here are a few examples:

Draw your own decorative features and banners here - there are no limits on your imagination.

... and now it's time to compose your own individual saying with hand lettering.

DIE KLEINEN DINGE SIND DAS, DIE JENIGEN GROSS MACHEN

Enjoy the small things. They make life wonderful.

Genieße die kleinen Dinge.
Sie machen das Leben großartig.

This is simply for you to trace.

CHALLENGE #LETTERGLÜCK

Now that you are familiar with a few fonts and lettering styles, it is time to do some practice exercises. And what would be better for this than a hand lettering challenge? OK, there are already a large number of these, but practice makes perfect! Perhaps you will succeed in pulling off this challenge in 30 days; it would certainly be worth a try and would be excellent training for your hand lettering skills. You do not have to produce masterpieces; it is much more a matter of staying on top of things.
In any case it should be fun!

01 **Happiness is possible**
02 **If you chase happiness you will rarely catch it.**
03 **Take time for the things that make you happy.**
04 **Then I just feel happy.**
05 **Feelings of happiness.**
06 **Anyone is entitled to a run of good luck.**
07 **The best recipe for happiness: think less.**
08 **Happiness begins when you forget the time..**
09 **Sometimes happiness whispers very softly: it's your turn.**
10 **Happiness is a way of travel, not a destination.**
11 **If something doesn't make me happy I don't need it.**
12 **Happiness is a brief pleasure, but leaves a long memory.**
13 **He who plants a garden plants happiness.**
14 **Happiness is the ability to recognize it.** *Carolyn Wells*
15 **Trust in your happiness and you will pull it towards you.** *Seneca*
16 **Today is a good day to be happy.**
17 **Happiness is when catastrophe takes a break.**
18 **Happiness is the energy of light.** *Beat Jan*
19 **There are many ways of achieving happiness, one of which is to stop moaning.**
Albert Einstein
20 **Learn to let go. That is the key to happiness.**
21 **My goal is to be happy, not perfect.**
22 **The time for happiness is today, not tomorrow.** *David Dunn*
23 **Happiness is free, and yet priceless.**
24 **You have to fight for happiness. Problems you get for nothing.**
25 **Happiness is enjoying what you are obliged to do and being allowed to do what you enjoy.** *Henry Ford*
26 **Today is my lucky day.**
27 **We need to waste a lot more time being happy.**
28 **Happiness is when your mind is dancing, your heart is breathing and your eyes are loving.**
29 **Happiness is doubled when shared.**
30 **Courage is the beginning of an action, but chance is the master of the end.**

You can get started with the challenge straight away here.
*And don't forget to post the fruits of your work on **#letterglück***

Creativity IS what YOU MAKE OF IT.

Finally, another great mantra to trace ...

... and use this space to practise your own version!

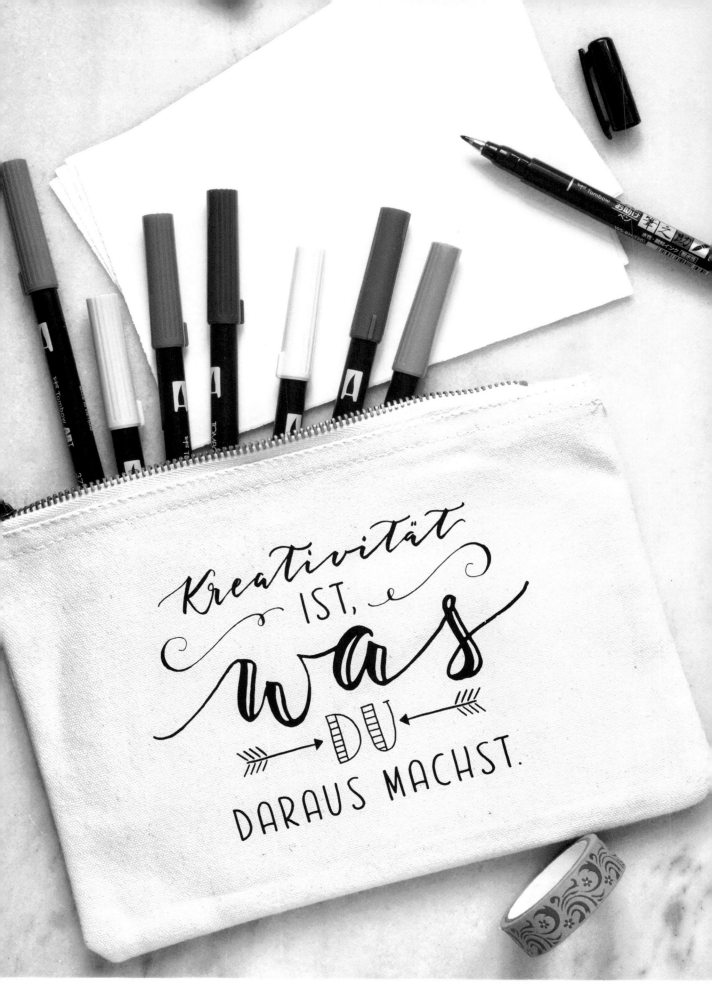

Small works of art created from letters and words - written and drawn by hand with love. Hand lettering gives you a little time for relaxation with pen and paper. Katja Haas introduces the art of beautiful writing presenting the different types of lettering, materials, all the basic principles and practical tips and tricks for your own designs.

Tuva Publishing
www.tuvapublishing.com

Address
Merkez Mah. Cavusbasi Cad. No:71
Cekmekoy - Istanbul 34782 / Turkey
Tel: +9 0216 642 62 62

Hand Lettering Workbook

Original title: Handlettering – Übungsheft by Katja Haas
First published in Germany in 2017 by Helmut Lingen Verlag GmbH.
Cover, design and illustrations: Helmut Lingen Verlag GmbH and Katja Haas.
All rights reserved

First Print
2019 / July

All Global Copyrights Belong To
Tuva Tekstil ve Yayıncılık Ltd.

Content
Art

 TuvaYayincilik TuvaPublishing
 TuvaYayincilik TuvaPublishing

Editor in Chief
Ayhan DEMİRPEHLİVAN

Project Editor
Kader DEMİRPEHLİVAN

Text & Illustrations
Katja HAAS

Graphic Designers
Ömer ALP
Abdullah BAYRAKÇI
Zilal ÖNEL

ISBN
978-605-7834-01-0